Comic Epitaphs

FROM THE VERY BEST

OLD GRAVEYARDS:

ILLUSTRATED

BY HENRY R. MARTIN

THE PETER PAUPER PRESS

MOUNT VERNON · NEW YORK

EPITAPH:
A MEMORIAL THAT
USUALLY LIES ABOVE
ABOUT THE ONE
THAT LIES BELOW

———————◆———————

THE FOLLOWING collection of gravestone inscriptions is hardly a serious historical one. Most of the items are genuine, but many are suspect, and a few are frankly contrived. In some cases genuine inscriptions have been somewhat altered; and the place names are not reliable. Scholars are therefore warned not to find fault; but all men — and also any women who choose — are invited to read further for a little ghoulish amusement.

THIS SPOT'S THE SWEETEST
I'VE SEEN IN MY LIFE
FOR IT RAISES MY FLOWERS
AND COVERS MY WIFE

LLANELLY

5

HERE LIES THE BODY OF
MARY ANN LOWDER
SHE BURST WHILE DRINKING
A SEIDLITZ POWDER:
CALLED FROM THIS WORLD
TO HER HEAVENLY REST:
SHE DRANK IT AND
SHE EFFERVESCED

STANWICH

———————◆———————

HERE IN THIS URN
FROM MALABAR
THE ASHES LIE
OF JONATHAN BARR:
HE SOUGHT A HIGHER LIFE
AFAR
AND TRAVELLED HOMEWARD
IN A JAR

NANTUCKET

6

TO THE SHORT MEMORY
OF MARVIN TRUEHAM:
REGRETTED BY ALL
WHO NEVER KNEW HIM

VERONICA

———◆———

TO THE MEMORY OF
ABRAHAM BEAULIEU
ACCIDENTALLY SHOT
APRIL 1844:
AS A MARK OF AFFECTION
FROM HIS BROTHER

LA POINTE

———◆———

HERE LIES ANN MANN;
SHE LIVED AN OLD MAID
BUT DIED AN OLD MANN

MANCHESTER

HERE LIES PECOS BILL
HE ALWAYS LIED
AND ALWAYS WILL:
HE ONCE LIED LOUD
HE NOW LIES STILL

GRAND FORKS

———◆———

UNDERNEATH THIS STONE
LIES POOR JOHN ROUND:
LOST AT SEA
AND NEVER FOUND

MARBLEHEAD

———◆———

On John Strange the Lawyer:

HERE LIES AN
HONEST LAWYER

. . .

THAT IS STRANGE

On John Rose and his Family:

THIS GRAVE'S
A BED OF ROSES

INGLISH COMBE

HERE LIES PAT MACHREE
THAT'S VERY TRUE:
WHO WAS HE? WHAT WAS HE?
WHAT'S THAT TO YOU?

CONNEMARA

HERE LIES TWO BROTHERS
BY MISFORTUN SEROUNDED
ONE DY'D OF HIS WOUNDS
AND THE OTHER WAS
DROWNDED

CHICHESTER

HE GOT A FISHBONE
IN HIS THROAT
WHICH MADE HIM SING
AN ANGEL'S NOTE

BEACON FALLS

10

SACRED TO THE MEMORY
OF ANTHONY DRAKE
WHO DIED FOR PEACE
AND DEAR QUIETNESS' SAKE:
HIS WIFE WAS FOREVER
SCOLDIN' AND SCOFFIN'
SO HE SOUGHT REPOSE
IN A $12 COFFIN

MARIETTA

———◆———

HERE LIES THE BODY
OF MARY GWYNNE
WHO WAS SO VERY
PURE WITHIN
SHE CRACKED THE SHELL
OF HER EARTHLY SKIN
AND HATCHED HERSELF
A CHERUBIM

CAMBRIDGE

JONATHAN GROBER
DIED DEAD SOBER

. . .

LORD THY WONDERS
NEVER CEASE

CLINKERTON

———◆———

BLOWN UPWARD
OUT OF SIGHT:
HE SOUGHT THE LEAK
BY CANDLELIGHT

WILTSHIRE

———◆———

THE DUST OF
MELANTHA GRIBBLING
SWEPT UP AT LAST
BY THE
GREAT HOUSEKEEPER

WOODVILLE

12

OWEN MOORE:
GONE AWAY
OWIN' MORE
THAN HE COULD PAY

BATTERSEA

13

MARY WEARY, HOUSEWIFE

. . .

DERE FRIENDS I AM GOING
WHERE WASHING AIN'T DONE
OR COOKING OR SEWING:
DON'T MOURN FOR ME NOW
OR WEEP FOR ME NEVER:
FOR I GO TO DO NOTHING
FOREVER AND EVER!

BELCHERTOWN

———◆———

DEATH HAS TAKEN
LITTLE JERRY
SON OF JOSEPH AND SERENA
HOWELLS:
SEVEN DAYS HE WRESTLED
WITH THE DYSENTERY
THEN HE PERISHED IN HIS
LITTLE BOWELS

STOWE

14

HERE LIES A SAILOR'S BRIDE
WHO WIDOWED WAS
BECAUSE OF THE TIDE:
IT DROWNED HER HUSBAND:
SO SHE DIED

YARMOUTH

On the Oxford Organist, Merideth:

HERE LIES ONE
BLOWN OUT OF BREATH
WHO LIVED A MERRY LIFE
AND DIED A MERIDETH

OXFORD

On Archbishop Potter:

ALACK AND WELL-A-DAY
POTTER HIMSELF
IS TURNED TO CLAY

JONATHAN GROOM

. . .

THE WEDDING DAY
APPOINTED WAS
AND WEDDING CLOTHES
PROVIDED:
BUT ERE THE DAY
DID COME, ALAS
HE SICKENED AND HE DIE DID

DEW BARTON

———◆———

HERE LIES MY WIFE
IN EARTHY MOULD
WHO WHEN SHE LIVED
DID NAUGHT BUT SCOLD:
GOOD FRIENDS GO SOFTLY
IN YOUR WALKING
LEST SHE SHOULD WAKE
AND RISE UP TALKING

BEDFORD

16

SEVEN WIVES I'VE BURIED
WITH AS MANY
A FERVENT PRAYER:
IF WE ALL SHOULD MEET
IN HEAVEN
WON'T THERE BE
TROUBLE THERE?

TYNGSBORO

———◆———

JOS. McKEE
HE DIED AT NASHVILLE
TENNESSEE
HE DIED OF
KRONIC DIAREE:
IT TRULY PAINFUL
MUST OF BEEN
TO DIE SO FAR AWAY
FROM KIN

KOKOMO

JOHN MACPHERSON
WAS A REMARKABLE PERSON:
HE STOOD SIX FOOT TWO
WITHOUT HIS SHOE:
AND HE WAS SLEW
AT WATERLOO

MACHNITTY

———————◆———————

WILBUR GUTTMANN
AND HIS WIFE
THEIR WARFARE IS
ACCOMPLISHED

CRUMBBLE

———————◆———————

HERE LIES A FATHER OF 29:
THERE WOULD HAVE BEEN MORE
BUT HE DIDN'T HAVE TIME

MOULTRIE

BRIEF EPITAPHS

On an Author:

HE HAS WRITTEN FINIS

On a Painter:

A FINISHED ARTIST

On an Angler:

HE'S HOOKED IT

On a Coal-miner:

GONE UNDERGROUND
FOR GOOD

On a Photographer:

TAKEN FROM LIFE

On a Gardener:

TRANSPLANTED

JOHN & IRA KEAPE

. . .

BENEATH THESE STONES
DO LIE
BACK TO BACK
MY WIFE AND I:
WHEN THE LAST LOUD TRUMP
SHALL BLOW,
IF SHE GETS UP
I'LL JUST LIE LOW

SARGENTVILLE

———◆———

ELIZA ANN
HAS GONE TO REST;
SHE NOW RECLINES
ON ABRAHAM'S BREAST:
PEACE AT LAST FOR ELIZA ANN
BUT NOT FOR
FATHER ABRAHAM

FARMINGTON

20

On an Infant:

SINCE I HAVE BEEN SO
QUICKLY DONE FOR,
I WONDER WHAT I WAS
BEGUN FOR

HAMMONDPORT

On the Four Husbands of Ivy Saunders:

HERE LIE MY HUSBANDS

1 · 2 · 3

AS STILL AS MEN

COULD EVER BE:

AS FOR THE FOURTH:

PRAISE BE TO GOD

HE STILL ABIDES

ABOVE THE SOD:

ABEL, SETH AND LEIDY

WERE THE FIRST 3 NAMES

AND TO MAKE THINGS TIDY

I'LL ADD HIS — JAMES

SHUTESBURY

———◆———

HERE LIES GEORDIE DENHAM

IF YE SAW HIM NOW

YE WADNA KEN HIM!

GARADOON

POOR MARTHA SNELL
HER'S GONE AWAY
HER WOULD IF HER COULD
BUT HER COULDN'T STAY:
HER HAD TWO SWOLN LEGS
AND A BADDISH COUGH
BUT HER LEGS IT WAS
AS CARRIED HER OFF

CHUTNEY

TO ALL MY FRIENDS
I BID ADIEU
A MORE SUDDEN DEATH
YOU NEVER KNEW:
AS I WAS LEADING
THE MARE TO DRINK
SHE KICKED AND KILLED ME
QUICKER'N A WINK

OXFORD, N. HAMP.

On a Husband and His Two Wives:

DEATH'S ADVANTAGE
OVER LIFE I SPYE:
HERE ONE HUSBAND WITH
TWO WYVES MAY LYE

WITHINGHAM

POKER JIM WILKINS
HIS LAST FULL HOUSE

MORISBURG

HERE LIES JOHN RACKET
IN HIS WOODEN JACKET:
KEPT NEITHER HORSES
NOR MULES
LIVED A HOG · DIED A DOG
LEFT ALL HIS MONEY
TO FOOLS

BELGRAVE

24

HE HAD SOME FAULTS
AND MANY MERITS
HE DIED OF DRINKING
ARDENT SPIRITS

LEAMINGTON

25

On a stone raised after four urns,
with the ashes of four wives,
had overturned in a gale:

STRANGER PAUSE

AND SHED A TEAR:

FOR MARY JANE

LIES BURIED HERE

MINGLED IN A MOST

SURPRISING MANNER

WITH SUSAN, JOY

AND PORTIONS OF HANNA

KENT

———◆———

EBENEZER PRICHARD

HERE LIES LOW

HAVING

FORSOOK LIFE

POISONED BY HIS WIFE

AND DR. ELI HORNBLOW

TIFFIN OAKS

WILHELMINA

. . .

NEURALGIA WORK'D
ON MRS. SMITH
TILL 'NEATH THE SOD
IT LAID HER:
SHE WAS A WORTHY
METHODIST
AND ANTI-DRINK CRUSADER

SKANEATELES

———◆———

SHE WAS NOT SMART
SHE WAS NOT FAIR
BUT HEARTS WITH GRIEF
FOR HER ARE SWELLIN'
ALL EMPTY STANDS
HER LITTLE CHAIR:
SHE DIED OF EATIN'
WATERMELON

TEANECK

DEAR SISTER

. . .

HERE LIES THE BODY
OF MARY FORD
WE HOPE HER SOUL
IS WITH THE LORD:
BUT IF FOR HELL
SHE'S CHANGED THIS LIFE
BETTER LIVE THERE
THAN AS J. FORD'S WIFE

SOWERSBY

———————◆———————

SHE LIVED WITH
HER HUSBAND
FIFTY YEARS
AND DIED IN THE
CONFIDENT HOPE
OF A BETTER LIFE

BURLINGTON

28

ELIZA, SORROWING
REARS THIS MARBLE SLAB
TO HER DEAR JOHN
WHO DIED OF EATING CRAB

CROUTON

On a Brewer:

POOR JOHN SCOTT
LIES BURIED HERE
THOUGH ONCE HE WAS
BOTH 'ALE AND STOUT:
NOW DEATH HAS DRAWN
HIS BITTER BIER
IN A BETTER WORLD
HE HOPS ABOUT

ISLINGTON

———◆———

On Mrs. Nott:

NOTT BORN · NOTT DEAD
NOTT CHRISTENED
NOTT BEGOT:
LO HERE SHE LIES
WHO WAS
AND WHO WAS NOTT

HADDINGTON

30

On a Music Teacher:

STEPHEN AND TIME
ARE NOW BOTH EVEN:
STEPHEN BEAT TIME
NOW TIME'S BEAT STEPHEN

CORNWALL

———◆———

HE CALLED
BILL SMITH
A LIAR

CRIPPLE CREEK

———◆———

STRANGER REJOICE:
THIS TOMB HOLDS
ARABELLA YOUNG
WHO ON MAY FIFTH · 1837
BEGAN TO HOLD
HER TONGUE

CHESTER

HERE LIE I
MARTIN ELGINBRODDE:
HAE MERCY O' MY SOUL
LORD GOD
AS I WAD SO
WERE I LORD GOD
AND YE WERE
MARTIN ELGINBRODDE

ELGIN

NICHOLAS TOKE

. . .

FIVE TIMES HE WIVED
BUT STILL SURVIVED:
TO SEEK A SIXTH HE
AT THE AGE OF 93
WALKED TO LONDON TOWN:
BUT THE JOURNEY
GOT HIM DOWN

KENSINGTON

HERE LIES MY WIFE
A SLATTERN AND SHREW:
IF I SAID I MISSED HER
I SHOULD LIE HERE, TOO!

SELBY

HERE LIES
JOHN DALRYMPLE:
HE PICKED
A PIMPLE

THRUSTONVILLE

HERE LIES INTERRED
BENEATH THESE STONES
THE BEARD, THE FLESH
AND EKE THE BONES
OF WREXHAM'S CLERK
OLD DANIEL JONES

WREXHAM

On Our Mother, Althea White,
Weight 309 Pounds:

OPEN, OPEN WIDE
YE GOLDEN GATES THAT LEAD
TO THE HEAVENLY SHORE:
EVEN FATHER SUFFERED
PASSING THROUGH
AND MOTHER
WEIGHS MUCH MORE

UNION CORNERS

———◆———

OUR FATHER LIES
BENEATH THE SOD:
HIS SPIRIT'S GONE
TO MEET HIS GOD:
WE NEVER MORE
SHALL HEAR HIS TREAD
OR SEE THE WEN
UPON HIS HEAD

NORTH BRANFORD

34

FIRST A COUGH
CARRIED ME OFF
THEN A COFFIN
THEY CARRIED ME OFF IN

BOSTON

On a Coroner, Who Hanged Himself:

HE LIVED
AND DIED
BY SUICIDE

WEST GRINSTEAD

On a Dentist:

STRANGER, TREAD
THIS GROUND WITH GRAVITY:
DENTIST BROWN IS FILLING
HIS LAST CAVITY

EDINBOROUGH

On a Bishop:

IN THIS HOUSE
WHICH I HAVE BORROWED
FROM THE WORMS
I LIE:
STOP, READER:
SMILE AS YOU BEHOLD
THE PALACE OF A BISHOP!

ISLE OF MAN

THIS STONE WAS RAISED
TO SARAH FORD
NOT SARAH'S VIRTUES
TO RECORD:
FOR THEY'RE WELL KNOWN
BY ALL THE TOWN:
NO, LORD: IT WAS RAISED
TO KEEP HER DOWN

KILMURRY

BLESS MY I I I I I
HERE I LIES
IN A SAD PICKLE
KILLED BY A ICICLE

BAMPTON

HERE LIES
HERMINA KUNTZ
TO VIRTUE QUITE UNKNOWN:
JESUS, REJOICE!
AT LAST
SHE SLEEPS ALONE

BELLE ISLE

———◆———

SACRED TO THE REMAINS OF
JONATHAN THOMPSON
A PIOUS CHRISTIAN AND
AFFECTIONATE HUSBAND

. . .

HIS DISCONSOLATE WIDOW
CONTINUES TO CARRY ON
HIS GROCERY BUSINESS
AT THE OLD STAND ON
MAIN STREET: CHEAPEST
AND BEST PRICES IN TOWN

HARWICHPORT

38

HERE LIES THE BODY
OF OUR DEAR ANNA
DONE TO DEATH
BY A BANANA:
IT WASN'T THE FRUIT
THAT DEALT THE BLOW
BUT THE SKIN OF THE THING
THAT LAID HER LOW

BURLINGTON

———————◆———————

HERE LIES I
AND MY TWO DAUGHTERS
KILLED BY DRINKING
CHELTENHAM WATERS:
IF WE HAD STUCK TO
EPSOM SALTS
WE WOULDN'T BE LYING
IN THESE HERE VAULTS

CHELTENHAM

39

HERE LIES THE BONES
OF JOSEPH JONES

. . .

WHEN FROM THE TOMB
TO MEET HIS DOOM
HE RISES AMIDST SINNERS:
TAKE HIM TO DWELL
IN HEAVEN OR HELL
WHICHEVER SERVES
BIG DINNERS

FLEMINGTON

———◆———

BENEATH THIS STONE
A LUMP OF CLAY
LIES UNCLE PETER DANIELS:
TOO EARLY IN THE
MONTH OF MAY
HE TOOK OFF HIS
WINTER FLANNELS

MEDWAY

On Jonathan Fiddle:

ON THE 22ND OF JUNE
JONATHAN FIDDLE
WENT OUT OF TUNE

HARTSCOMBE

HERE LIES CUT DOWN
LIKE UNRIPE FRUIT
THE WIFE OF
DEACON AMOS SHUTE:
SHE DIED OF DRINKING
TOO MUCH COFFEE
ANNY DOMINY 1840

ROXBURY

————◆————

HERE LIES OLD
AUNT HANNAH PROCTOR
WHO PURGED BUT DIDN'T
CALL THE DOCTOR:
SHE COULDN'T STAY
SHE HAD TO GO

. . .

PRAISE GOD FROM WHOM
ALL BLESSINGS FLOW

MEDWAY

On a Hanged Sheep-stealer:

HERE LIES THE BODY
OF THOMAS KEMP
WHO LIVED BY WOOL
AND DIED BY HEMP

BLETCHLEY

On Dr. Fuller:

HERE LIES FULLER'S EARTH

On Peter Robinson:

HERE LIES THE PREACHER
JUDGE
AND POET PETER:
WHO BROKE THE LAWS OF
GOD AND MAN
AND METER

BRISTOL

43

HERE LIES JANE SMITH
WIFE OF THOMAS SMITH
MARBLE CUTTER:
THIS MONUMENT ERECTED
BY HER HUSBAND
AS A TRIBUTE
TO HER MEMORY

. . .

MONUMENTS OF THIS STYLE
ARE 250 DOLLARS

ANNAPOLIS

———◆———

BENEATH THIS STONE
OUR BABY LIES
HE NEITHER CRIES
NOR HOLLERS:
HE LIVED ON EARTH
JUST TWENTY DAYS
AND COST US FORTY DOLLARS

BENNINGTON

44

On Ezekiel Pease:

HE IS NOT HERE
BUT ONLY HIS POD:
HE SHELLED OUT HIS PEAS
AND WENT TO HIS GOD

NANTUCKET

On a Bachelor:

AT THREESCORE WINTERS'
END I DIED
A CHEERLESS BEING
SOLE AND SAD:
THE NUPTIAL KNOT
I NEVER TIED
AND WISH MY FATHER
NEVER HAD

BECKETTOWN

———◆———

HERE LIES CINTHY STOUT
MY WIFE:
WE LIVED SIXTY ANNOS OUT
IN PAIN AND STRIFE:
DEATH CAME AT LAST
TO SET ME FREE:
I WAS GLAD: SO WAS SHE

CRUMPERTON

46

MY WIFE IS DEAD
AND HERE SHE LIES:
NOBODY LAUGHS
AND NOBODY CRIES:
WHERE SHE IS GONE TO
AND HOW SHE FARES
NOBODY KNOWS
AND NOBODY CARES

STROUD

———◆———

CHARITY, WIFE OF
GIDEON BLIGH
UNDERNEATH THIS STONE
DOTH LIE:
NAUGHT WAS SHE EVER
KNOWN TO DO
THAT HER HUSBAND
TOLD HER TO

DEVONSHIRE

47

AGAINST HIS WILL
HERE LIES GEORGE HILL:
WHO FROM A CLIFF
FELL DOWN QUITE STIFF

KINGSTON

———◆———

HERE LYES MY POOR WYFE
WITHOUT BED OR BLANKET
BUT DEAD AS ANY STONE:
GOD BE THANKET

OXFORD

———◆———

On a Farmer's Daughter, Letitia:

GRIM DEATH
TO PLEASE HIS PALATE
HAS TAKEN MY LETTICE
TO PUT IN HIS SALLAT

IPSWICH

48

On a Miser:

POORLY LIVED
AND POORLY DIED
POORLY BURIED
AND NO ONE CRIED

WARWICK

49

On a Second Stone, for a Second Wife:

HERE LIES THE BODY
OF SARAH SEXTON:
SHE WAS A WIFE
THAT NEVER VEX'D ONE:
I CAN'T SAY AS MUCH
FOR THE FIRST ONE
UNDER THE NEXT STONE

FALKIRK

———◆———

HERE LIES WILLIAM TEAGUE
LOVER OF HIS BOTTLE
WHO LEFT THIS LIFE
MURDERED BY THE MEANNESS
OF HIS WIFE
CHAIRMAN OF THE LOCAL
ANTI-SALOON LEAGUE
AND DR. AMOS THROTTLE

GREELEY

HERE LIES THE
JONES BOYS TWINS
AS DEAD AS NITS:
ONE DIED OF FEVER
ONE OF FITS

SIERRA CITY

TEARS CANNOT
RESTORE HER:
THEREFORE I WEEP

KEENE

THE LITTLE HERO
THAT LIES HERE
WAS CONQUERED BY
THE DIARRHOEA

PORTLAND, VT.

51

TO THE GREEN MEMORY OF
WILLIAM HAWKINS
GARDENER:
PLANTED HERE
WITH LOVE AND CARE
BY HIS
GRIEVING COLLEAGUES

DAVENPORT

———◆———

SACRED TO THE MEMORY
OF JARED BATES

. . .

HIS WIDOW, AGED 24
LIVES AT 7 ELM STREET
HAS EVERY QUALIFICATION
FOR A GOOD WIFE
AND YEARNS
TO BE COMFORTED

AURORA FALLS

On Emma and Maria Littleboy:

TWO LITTLEBOYS LIE HERE.
YET STRANGE TO SAY
THE LITTLEBOYS
ARE GIRLS

HORNSEY

IF THERE IS A FUTURE WORLD
MY LOT WILL NOT BE BLISS:
BUT IF THERE IS NO OTHER
I'VE MADE THE MOST OF THIS

DESINGWOKE

SHE LIVED BY VIRTUE
HOPING FOR IMMORTALITY
AND DIED BY CHOLERA
CAUSED BY EATING
UNRIPE FRUIT:
READER, GO THOU
AND DO LIKEWISE

ASHTABULA

HE DIED OF A QUINSY
AND WAS BURIED AT BINSEY

54

On William Wilson:

HERE LIETH

W. W.

WHO NEVER MORE

WILL TROUBLE YOU

TROUBLE YOU

LAMBETH

Tombstone Typographical Errors

THY GLASS IS RUM

GONE TO BE AN ANGLE

LORD, SHE IS THIN

A BOTTLE SCARRED VETERAN

corrected to:

A BATTLE SCARED VETERAN

STRANGER CALL THIS NOT
A PLACE OF GLOOM:
TO ME IT IS A PLEASANT SPOT
MY HUSBAND'S TOMB

BISMARCK

I'M SAFE IN SAYING
SHE'S GONE UP HIGHER:
NARY A DEVIL
WOULD WANT MARIA

SOMERSET

TALKED TO DEATH
BY FRIENDS

. . .

CHARTER MEMBER OF THE
FRIDAY BRIDGE CLUB

FLAT ROCK CITY

56

Erected by the Vigilante Committee:

HERE LIES THE BODY
OF ARKANSAW JIM:
WE MADE THE MISTAKE
BUT THE JOKE'S ON HIM

CULVER CITY

THIS EMPTY URN IS
SACRED TO THE MEMORY
OF JOHN REVERE
WHO DIED ABROAD
IN FINISTERE:
IF HE HAD LIVED
HE WOULD HAVE BEEN
BURIED HERE

CONNEMORA

IN MEMORY OF
ELLEN SHANNON
WHO WAS FATALLY BURNED
BY THE
EXPLOSION OF A LAMP
FILLED WITH
DANFORTH'S NON-EXPLOSIVE
BURNING FLUID

GIRARD, PA.

HERE LIES THE BODY
OF LADY O'LOONEY:
SHE WAS BLAND
PASSIONATE, AND
DEEPLY RELIGIOUS:
ALSO SHE PAINTED IN
WATERCOLORS
AND SENT SEVERAL PICTURES
TO THE EXHIBITION:
SHE WAS FIRST COUSIN TO
LADY JONES:
AND OF SUCH IS
THE KINGDOM OF HEAVEN

DORSETSHIRE

———◆———

On a Traveling Salesman:

MY TRIP IS ENDED:
SEND MY SAMPLES HOME

HOBOKEN

Poor Richard's Own Epitaph:

THE BODY OF
BENJAMIN FRANKLIN
PRINTER,
LIKE THE COVERING
OF AN OLD BOOK
ITS CONTENTS TORN OUT
AND STRIPT OF ITS LETTERING
AND GILDING
LIES HERE, FOOD FOR WORMS;
BUT THE WORK
SHALL NOT BE LOST,
IT WILL (AS HE BELIEVED)
APPEAR ONCE MORE,
IN A NEW
AND MORE BEAUTIFUL EDITION,
CORRECTED AND AMENDED
BY THE AUTHOR

On Alexander the Great:

THIS MOUND NOW
IS LARGE ENOUGH FOR HIM
FOR WHOM ALL EARTH
WAS NOT

———◆———

On Shakespeare's Tomb:

GOOD FREND
FOR JESUS SAKE FORBEARE,
TO DIGG THE DUST
ENCLOASED HEARE:
BLESE BE THE MAN
THAT SPARES THESE STONES,
AND CURST BE HE
THAT MOVES MY BONES

STRATFORD

———◆———

Legend on Hypochondriac's Tombstone:

I TOLD YOU I WAS
SICK